Extra-Bold
Alphabets

Extra-Bold Alphabets

100 COMPLETE FONTS

Selected and Arranged by

Dan X. Solo

from the
Solotype Typographers Catalog

Dover Publications, Inc., New York

Copyright © 1993 by Dover Publications, Inc.

Published in Canada by General Publishing Company, Ltd., 30 Lesmill Road, Don Mills, Toronto, Ontario.
Published in the United Kingdom by Constable and Company, Ltd., 3 The Lanchesters, 162–164 Fulham Palace Road, London W6 9ER.

Extra-Bold Alphabets: 100 Complete Fonts is a new work, first published by Dover Publications, Inc., in 1993.

DOVER *Pictorial Archive* SERIES

Manufactured in the United States of America
Dover Publications, Inc., 31 East 2nd Street, Mineola, N.Y. 11501

Library of Congress Cataloging-in-Publication Data

Extra-bold alphabets : 100 complete fonts / selected and arranged by Dan X.
 Solo from the Solotype Typographers catalog.
 p. cm. — (Dover pictorial archive series)
 ISBN 0-486-27522-1 (pbk.)
 1. Type and type-founding—Boldface type. 2. Printing—Specimens. 3.
 Alphabets. I. Solo, Dan X. II. Solotype Typographers. III. Series.
 Z250.5.B64E94 1993
 686.2'24—dc20 92-40103
 CIP

Aachen Bold

ABCDEFGHIJKL
MNOPQRSTUV
WXYZ (&;!?)

abcdefghijklmn
opqrstuvwxyz

$1234567890

1

Accent

ABCDEFGHI
JKLMNOPQR
STUVWXYZ
[&;!?]
abcdefghijk
lmnopqrst
uvwxyz

1234567890

Adriana

ABCDEFGHI
JKLMNOPQ
RSTUVWX
YZ(&:!?)
abcdefgh
ijklmnopq
rstuvwxy
$Z¢
1234567890

ALPHABET SOUP

ABCDEFGHIJKL
MNOPQRST
UVWXYZ

(&;!?)

$1234567890¢

American Typewriter Bold

ABCDEFGHI
JKLMNOPQR
STUVWXYZ
(&;!?)
abcdefghijkl
mnopqrstu
vwxyz

$1234567890

Americana Black

ABCDEFGH
IJKLMNOPQ
RSTUVWX
YZ(&;!?)
abcdefghijk
lmnopqrst
uvwxyz
1234567890

ANONYMOUS

ABCDEFGHIJKL
MNOPQRSTUV
WXYZ (&;!?)

$1234567890¢

Antique Olive Black

ABCDEFGHI
JKLMNOPQR
STUVWXYZ
(&;!?)
abcdefghijk
lmnopqrst
uvwxyz

$1234567890

Aquarius 8

ABCDEFGHIJKL
MNOPQRSTUVW
XYZ (&;!?)

abcdefghijklmno
pqrstuvwxyz

$1234567890

ARGOSY WOOD

ABCDEFG
HIJKLMN
OPQRSTU
VWXYZ
&,;!$

1234567890

Arpad Bold

ABCDEFGHIJK
LMNOPQRSTU
VWXYZ (&;!?)

abcdefghijklmn
opqrstuvwxyz

$1234567890

Aster Black

ABCDEFGHI
JKLMNOPQR
STUVWXYZ
(&;!?)
abcdefghijkl
mnopqrstu
vwxyz

1234567890

BANKER'S ROMAN

ABCDEFG
HIJKLMN
OPQRSTU
VWXYZ
&;!?

1234567890

BASSO

ABCDEFGHIJKLM
NOPQRSTUVWXYZ

(&;!?)

$1234567890¢

Bauhaus Heavy

ABCDEFGHIJK
LMMNNOPQRS
STUVWXXYZ
(&;!?)
abcdeefghijkl
mnopqrrsstu
vwxxyyz

$1234567890¢

Belwe Bold

ABCDEFGHI
JKLMNOPQR
STUVWXYZ
(&;!?)
abcdefghijkl
mnopqrstu
vwxyz

$1234567890¢

Benguiat Bold

ABCDEFGHI
JKLMNOPQR
STUVWXYZ
(&;!?)
abcdefghijk
lmnopqrst
uvwxyz
$1234567890

Benguiat Bold Italic

ABCDEFGHI
JKLMNOPQR
STUVWXYZ
(&;!?)
abcdefghijk
lmnopqrst
uvwxyz

1234567890

Bernhard Gothic Extra Heavy

ABCDEEFGHIJ
KKLMNOPQRR
STUVWXYZ
&;!?
aabcdefghijklm
nopqrsstuvwxyz

$1234567890¢

Beton Extrabold

ABCDEFGHIJ
KLMNOPQRST
UVWXYZ
(&;!?)
abcdefghijklm
nopqrstuv
wxyz

$1234567890

20

Bocklin Bold

ABCDEFGHII
KLMNOPQRST
UVWXYZ
(&;!?)

abcdefghijkl
mnopqrst
uvwxyz

$1234567890

BOND BLACK

ABCDEFGH
IJKLMNOPQ
RSTUVW
XYZ

(&;!?)
$1234567890

Book Jenson Bold

ABCDEFGHI
JKLMNOPQRS
TUVWXYZ
(&;!?)
abcdefghijklmn
opqrstuvwxyz

$1234567890¢

British Extra Bold

ABCDEFGH
IJKLMNOP
QRSTUVW
XYZ (&,-!?$)
abcdefghijk
lmnopqrst
uvwxyz
1234567890

Brittany Extra Bold

ABCDEFGHIJK
LMNOPQRST
UVWXYZ
&,;!?

abcdefghijkl
mnopqrstu
vwxyz

1234567890$

Caslon Black

ABCDEFGHIJ
KLMNOPQRST
UVWXYZ
(&;!?)

abcdefghijkl
mnopqrstu
vwxyz

$1234567890¢

Century Schoolbook Black

ABCDEFGHI
JKLMNOPQR
STUVWXYZ
(&;!?)
abcdefghijkl
mnopqrstu
vwxyz

$1234567890

CHARGER BOLD

ABCDEFGHIJK
LMNOPQRSTUV
WXYZ

(&;!?)
$1234567890¢

CHICKAMAUGA

ABCDEFGHI

JKLMNOPQ

RSTUVWXY

Z

Churchward Brush

ABBCDEFGHIJK
LMNOPQRSTUV
WXYZ(&;!?)

abcdefghijklmn
opqrstuvwxyz

1234567890$

Churchward Brush Italic

ABCDEFGHIJK
LMNOPQRSTUV
WXYZ (&;!?)

abcdefghijklmn
opqrstuvwxyz

1234567890$

City Black

ABCDEFGHIJKL
MNOPQRSTUV
WXYZ[&;!?]

abcdefghijklm
nopqrstuv
wxyz

$1234567890

Clearface Gothic Extrabold

ABCDEFGHIJKL
MNOPQRSTUV
WXYZ &;!?

abcdefghijklmn
opqrstuvwxyz

$1234567890¢

Clearface Roman Thick

ABCDEFGHIJ
KLMNOPQRST
UVWXYZ
(&;!?)

abcdefghijklm
nopqrstuvwxyz

$1234567890

Cooper Black

ABCDEFGH
IJKLMNOPQ
RSTUVWX
YZ [&;!?]

abcdefghijk
lmnopqrst
uvwxyz

$1234567890

Cooper Black Italic

ABCDEFGHI
JKLMNOPQR
STUVWXYZ
(&;!?)

abcdefghijkl
mnopqrst
uvwxyz

$1234567890¢

Copperplate Washington

ABCDEFGH
IJKLMNOPQ
RSTUVW
XYZ (&;!?)
abcdefghijk
lmnopqrst
uvwxyz
$12
34567890

Corvenus Bold

ABCDEFGHIJK
LMNOPQRSTUV
WXYZ (&;!?)

abcdefghijklmn
opqrstuvwxyz

$1234567890¢

Datilo Ultra Black

ABCDEFGHI
JKLMNOPQR
STUVWXYZ
(&;!?)
abcdefghijkl
mnopqrstu
vwxyz
1234567890

Della Robbia Heavy

ABCDEFGHIJ
KLMNOPQRST
UVWXYZ
(&;!?)

abcdefghijklmn
opqrstuvwxyz

$1234567890¢

Dolmen

ABCDEFGHI
JKLMNOPQRS
TUVWXYZ

abcdefghij
klmnopqrst
uvwxyz

&;!?$

1234567890

Doric Italic

ABCDEFGHI
JKLMNO
PQRSTUVW
XYZ (&;!?)
abcdefghijkl
mnopqrst
uvwxyz
1234567890

ECLIPSE GOTHIC

ABCDEFGHIJ
KLMNOPQRS
TUVWXYZ
(&;!?)

$1234567890

Egizio Bold

ABCDEFGH
IJKLMNOPQ
RSTUVWX
YZ (&;!?)
abcdefghijkl
mnopqrstu
vwxyz

$1234567890

Egyptian Bold Condensed

ABCDEFGHIJKL
MNOPQRSTUV
WXYZ(&;!?)

abcdefghijklmn
opqrstuvwxyz

$1234567890¢

Eightball

ABCDEFG
HIJKLMNO
PQRSTUV
WXYZ&:!?
abcdefghijkl
mnopqrstu
vwxyz
123
4567890

Elizabethan

ABCDEFGHI
JKLMNOPQRS
TUVWXYZ
(&;!?)
abcdefghijklm
nopqrstuv
wxyz
1234567890$¢

Elm Gothic

ABCDEFGHIJKLMN
OPQRSTUVWXYZ
(&;!?)

abcdefghijklmno
pqrstuvwxyz

$1234567890¢

Eras Ultra

ABCDEFGHI
JKLMNOPQR
STUVWXYZ
(&;!?)
abcdefghijk
lmnopqrstu
vwxyz

$1234567890

Ernie

ABCDEFGHIJK
LMNOPQRSTU
VWXYZ (&;!?)

abcdefghijkl
mnopqrst
uvwxyz

$1234567890¢

Folio Extrabold

ABCDEFGHI
JKLMNOPQR
STUVWXYZ
(&;!?)
abcdefghijk
lmnopqrst
uvwxyz

$1234567890

Fortuna Extrabold

ABCDEFGH
IJKLMNOP
QRSTUVW
XYZ &;!?

abcdefghijk
lmnopqrst
uvwxyz

$1234567890¢

Friz Quadrata Extrabold

ABCDEFGHI
JKLMNOPQRS
TUVWXYZ
(&;!?)
abcdefghijkl
mnopqrstu
vwxyz

$1234567890¢

Futura Extrabold

ABCDEFGHIJ
KLMNOPQRS
TUVWXYZ
(&¿!?)
abcdefghijkl
mnopqrstu
vwxyz

$1234567890

GEM GOTHIC

ABCDEFGHIJKL
MNOPQRSTU
VWXYZ
(&;!?)

$
1234
567890

Globe Gothic Bold

ABCDEFGHIJK
LMNOPQRSTUV
WXYZ (&;!?)

abcdefghijklmn
opqrstuvwxyz

$1234567890¢

Goudy Heavyface

ABCDEFGHI
JKLMNOPQR
STUVWXYZ
(&;!?)
abcdefghijkl
mnopqrstu
vwxyz
1234567890

Goudy Heavyface Italic

ABCDEFGH
IJKLMNOP
QRSTUVW
XYZ (&;!?)
abcdefghijkl
mnopqrstu
vwxyz

$1234567890

Granby Elephant Condensed

ABCDEFGHIJK
LMNOPQRSTU
VWXYZ (&;!?)

abcdefghijklm
nopqrstuvwxy
z

1234567890$¢

GRANBY SPUR

ABCDEFG

· · · · · · · · · · · · · · · · · · · ·

HIJKLMN

· · · · · · · · · · · · · · · · · · · ·

OPQRSTU

· · · · · · · · · · · · · · · · · · · ·

VWXYZ

Grassmere Heavy

ABCDEFGHIJKL
MNOPQQRSTU
VWXYZ (&;!?)

abcdefghijklm
nopqrstuvwxyz

1234567890$

Harlem Script

ABCDEFGHIJ
KLMNOPQRST
UVWXYZ
(&;!?)

abcdefghijklm
nopqrstuvwxyz

1234567890

HARMONY

ABCDEFGH
IJKLMNOP
QRSTUVW
XYZ

$

1234567890

Hotspur Extra Bold

ABCDEFGHIJK
LMNOPPQRRST
UVWWXYZ
(&;!?)
abcdeffghijjkl
mnopqrrstuvww
xyz

1234567890$

Ibsen

ABCDEFGHIJKLMN
OPQRSTUVWXYZ
(&;!?)

abcdefghijklmno
pqrstuvwxyz

$1234567890¢

JODY

ABCDEFGHIJK
LMNOPQRSTU
VWXYZ (&;!?)
abcdefghijklmn
opqrstuvwxyz

$

1234567890

Korinna Heavy

ABCDEFGH
IJKLMNOPQ
RSTUVW
XYZ (&;!?)
abcdefghijkl
mnopqrst
uvwxyz

1234567890

LoType Bold

ABCDEFGHI
JKLMNOPQR
STUVWXYZ
(&;!?)

abcdefghijk
lmnopqrst
uvwxyz

1234567890$

Marianna Black

ABCDEFGHIJK
LMNOPQRST
UVWXYZ(&;?!)

abcdefghijkl
mnopqrst
uvwxyz

$1234567890

Neil Bold

ABCDEFGHIJKL
MNOPQRST
UVWXYZ
(&:!?)
abcdefghijklm
nopqrstuvw
xyz

$1234567890¢

NEULAND BLACK

ABCDEFGH
IJKLMNOPQ
RSTUVWX
YZ (&;!?')

1234567890

Novarese Ultra

ABCDEFGHI
JKLMNOPQR
STUVWXYZ
(&;!?)
abcdefghijkl
mnopqrst
uvwxyz

1234567890

Optykos Bold Italic

ABCDEFGHIJKL
MNOPQRSTUV
WXYZ (&";:!?)

abcdefghijklm
nopqrstuvw
xyz

1234567890$¢

Palatino Black

ABCDEFGHIJ
KLMNOPQRS
TUVWXYZ
(&;!?)
abcdefghijklm
nopqrstuvwxyz

$1234567890¢

Perpetua Super

ABCDEFGHIJ
KLMNOPQRST
UVWXYZ&;!?

abcdefghijklmn
opqrstuvwxyz

$1234567890¢

Polar

ABCDEFGHIJ
KLMNOPQRST
UVWXYZ
(&;!?)
abcdefghijkl
mnopqrstu
vwxyz

1234567890

Pueblo

ABCDEFGHIJ
KLMNOPQRST
UVWXYZ
[&;!?]
abcdefghijkl
mnopqrstu
vwxyz

$1234567890¢

Quorum Ultra

ABCDEFGHIJ
KLMNOPQRST
UVWXYZ
(&;!?)
abcdefghijklm
nopqrstuv
wxyz

$1234567890¢

Rockwell Extrabold

ABCDEFGHI
JKLMNOPQ
RSTUVWXYZ

abcdefghijk
lmnopqrs
tuvwxyz
&,!?
1234567890$

Rodeo

ABCDEFGHI
JKLMNOPQR
STUVWXYZ
&;!?
abcdefghijkl
mnopqrstu
vwxyz

$1234567890

Romana Black

ABCDEFGHIJKL
MNOPQRSTUV
WXYZ &;!?

abcdefghijklmno
pqrstuvwxyz

$1234567890¢

Samson

ABCDEFGHI
JKLMNOPQR
STUVWXYZ
(&;!?)
abcdefghijk
lmnopqrst
uvwxyz

1234567890

Schadow Antiqua Bold

ABCDEFGHIJ
KLMNOPQRST
UVWXYZ
(&;!?)
abcdefghijkl
mnopqrst
uvwxyz

$1234567890¢

Sphinx

ABCDEFG
HIJKLMNO
PQRSTUV
WXYZ &;!?

abcdefghij
klmnopqr
stuvwxyz

1234567890

Sphinx Italic

ABCDEFG
HIJKLMNO
PQRSTUV
WXYZ &;!?

abcdefghi
jklmnopq
rstuvwxyz
$12
34567890

Stabile Extrabold

ABCDEFGHIJKL
MNOPQRSTUV
WXYZ (&;!?)

abcdefghijkl
mnopqrstuv
wxyz

$1234567890¢

STEAMBOAT SHADED

ABCDEFG
HIJKLMN
OPQRSTU
VWXYZ
(&;!?)

123
4567890

Stephania Bold

ABCDEFGHI
JKLMNOPQR
STUVWXYZ
(&;!?)
abcdefghijkl
mnopqrst
uvwxyz

1234567890

Stratford Black

ABCDEFGH
IJKLMNOPQ
RSTUVWX
YZ(&;!?)
abcdefghijkl
mnopqrstu
vwxyz
1234567890$¢

Stymie Black

ABCDEFGHIJ
KLMNOPQRST
UVWXYZ &;!?

abcdefghijklm
nopqrstuv
wxyz

$1234567890

Super Dooper

ABCDEFGHIJKL
MNOPQRSTU
VWXYZ
(&;!?)
abcdefghijkl
mnopqrstu
vwxyz
$1234567890¢

Tabasco Bold

ABCDEFGHIJ
KLMNOPQRST
UVWXYZ
(&;!?)

abcdefghijkl
mnopqrstu
vwxyz

$1234567890¢

Tamil Heavy

ABCDEFGHIJK
LMNOPQRSTUV
WXYZ(&;!?)

abcdefghijklm
nopqrstuv
wxyz

$1234567890¢

Texan

ABCDEFG
HIJKLMNO
PQRSTUV
WXYZ (&;!?)
abcdefghij
klmnopqrs
tuvwxyz

$12
34567890

Thorowgood Italic

ABCDEFG
HIJKLMNO
PQRSTUV
WXYZ (&;!?)
abcdefghi
jklmnopqrst
uvwxyz

1234567890

Thorowgood Roman

ABCDEFGH
IJKLMNOP
QRSTUVW
XYZ (&;!?)
abcdefghijk
lmnopqrst
uvwxyz
1234567890

TOO MUCH OPAQUE

ABCDEFGHI
JKLMNOPQ
RSTUVWXYZ
(&;!?)

1234567890

Ultra Bodoni

ABCDEFGH
IJKLMNO
PQRSTUVW
XYZ&;!?
abcdefghijkl
mnopqrst
uvwxyz

1234567890

Ultra Bodoni Italic

ABCDEFGH
IJKLMNO
PQRSTUVW
XYZ&;;!?
abcdefghijkl
mnopqrst
uvwxyz

1234567890

Weigand's Ad Bold

ABCDEFGHIJ
KLMNOPQRS
TUVWXYZ
(&;!?)

abcdefghijkl
mnopqrstu
vwxyz

$1234567890¢